W9-CGW-761

NA1

NATURE'S DESIGN
A PHOTOGRAPHIC ESSAY

by
Theodore D. Walker
A.S.L.A.

PDA Publishers Corporation

Additional copies may be ordered from: **PDA PUBLISHERS CORP.**
Box 3075
West Lafayette, Indiana
47906

Printed in the United States of America

To begin...

 The collection of photographs which forms this essay was gathered by the author over a period of years while traveling throughout the United States. The distance of the camera to the object varies from a few inches to a few feet thus representing a relative closeup view. Included are such objects as sand and rock; the trunks, bark, branches, and foliage of plants; ice, snow, and frost; moss and fungi; and clouds, sky, and water.

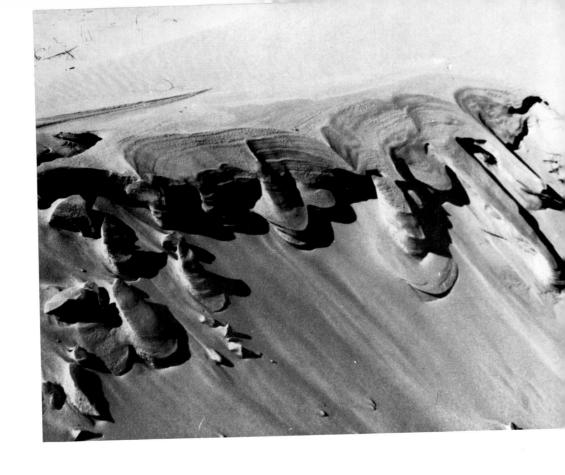

4

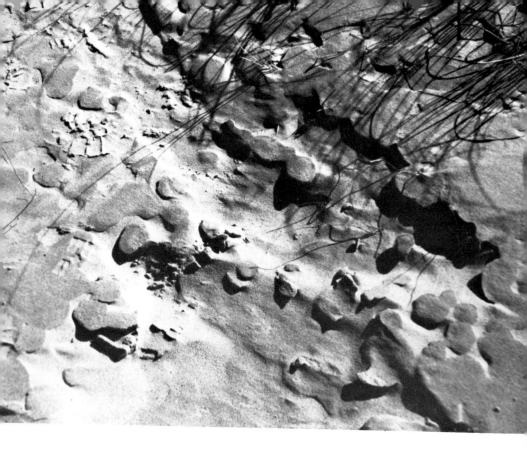

5

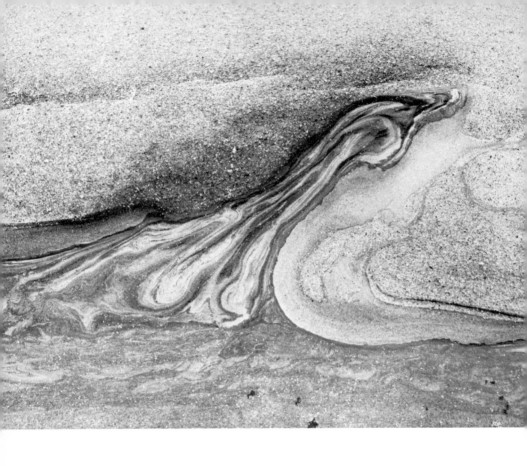

6

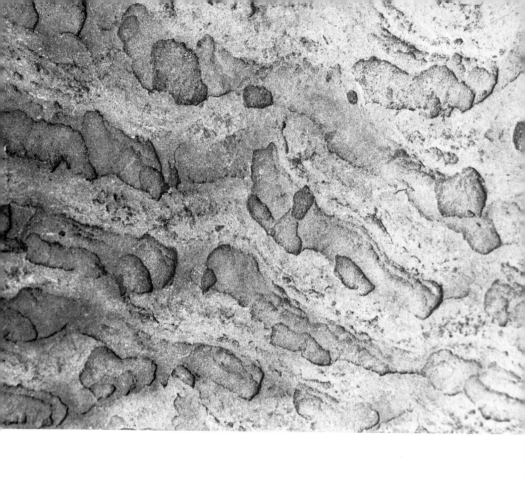

7

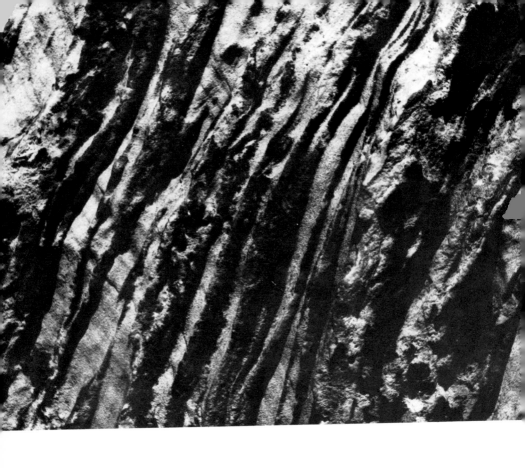

8

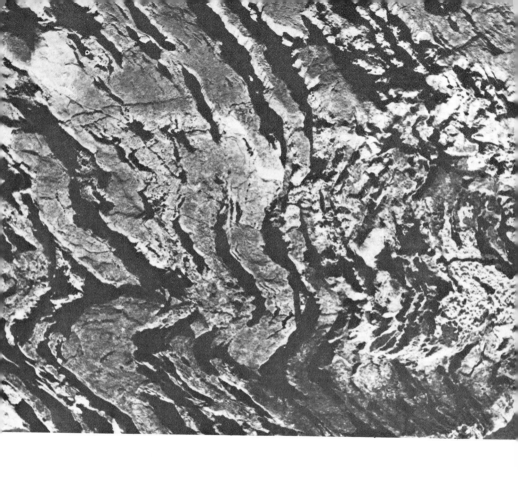

10

11

12

13

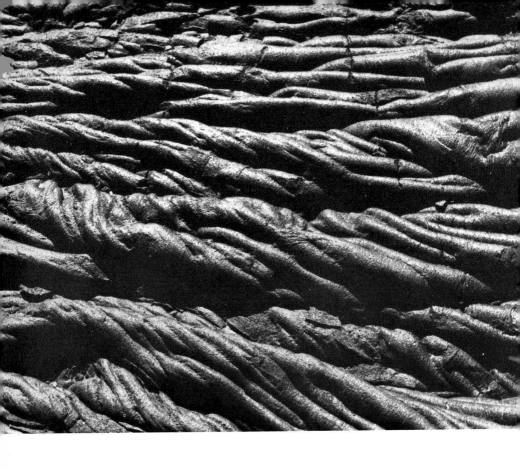

14

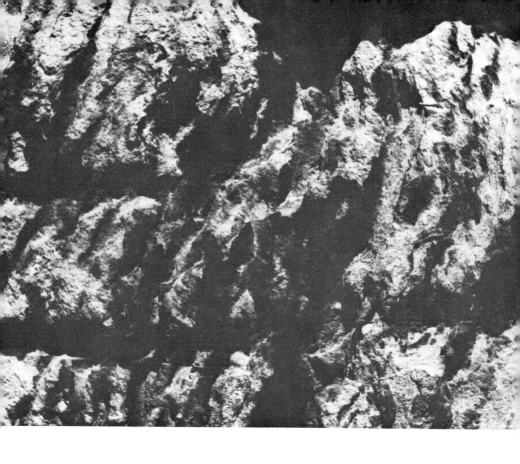

15

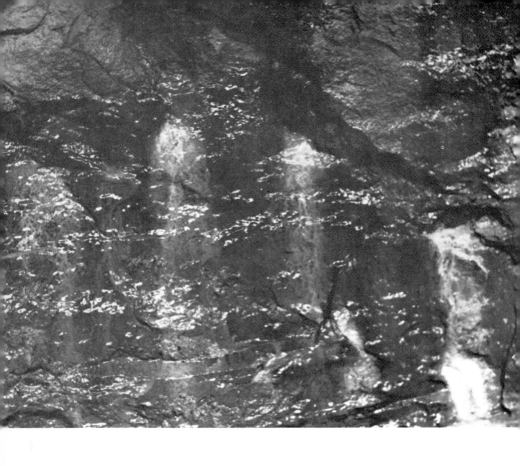

16

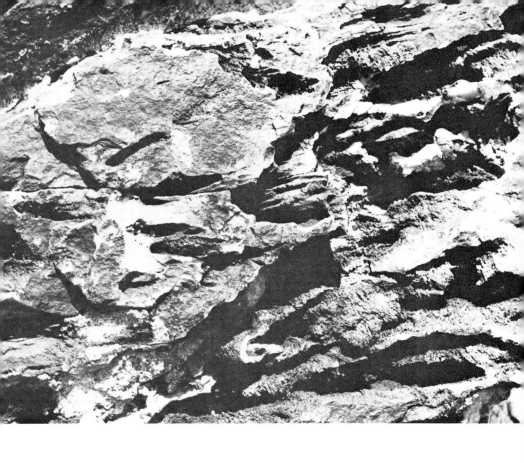

18

20

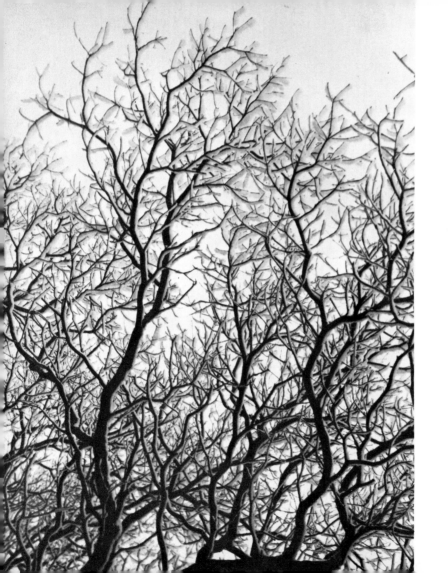

22

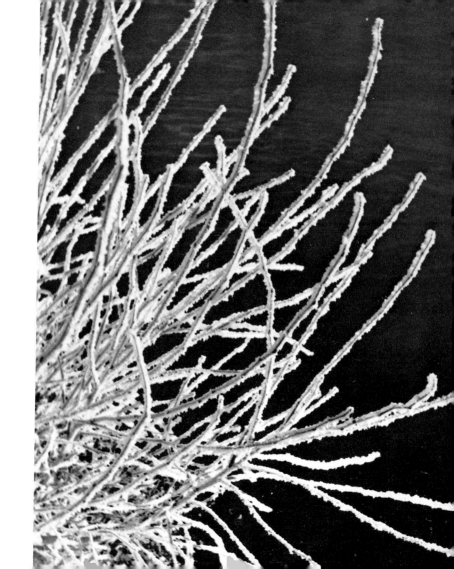

23

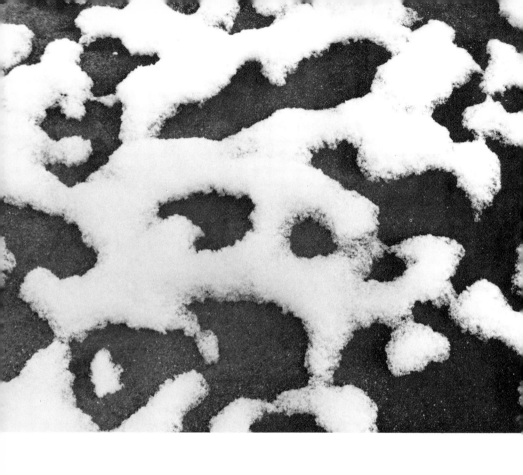

24

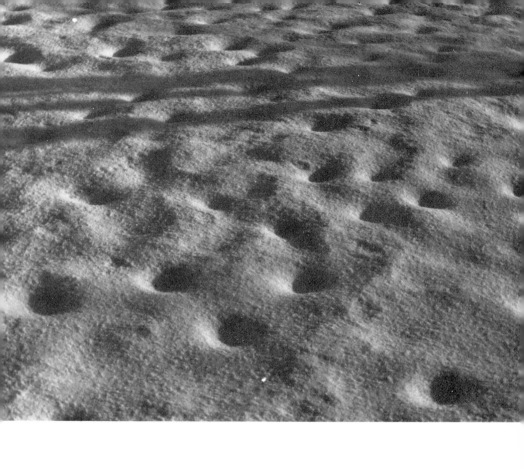

26

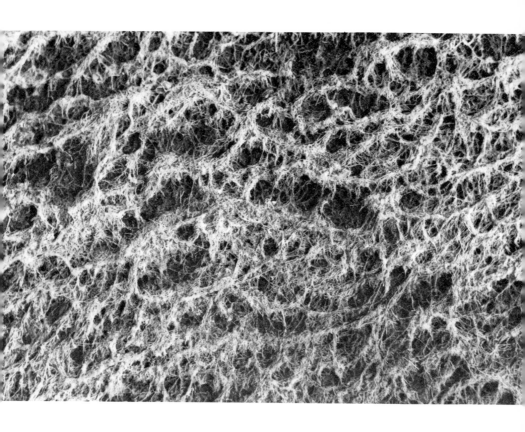

27

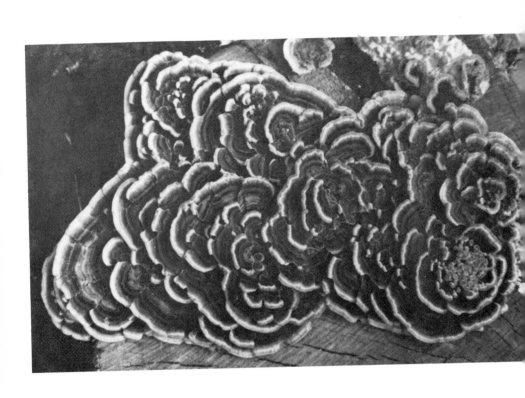

28

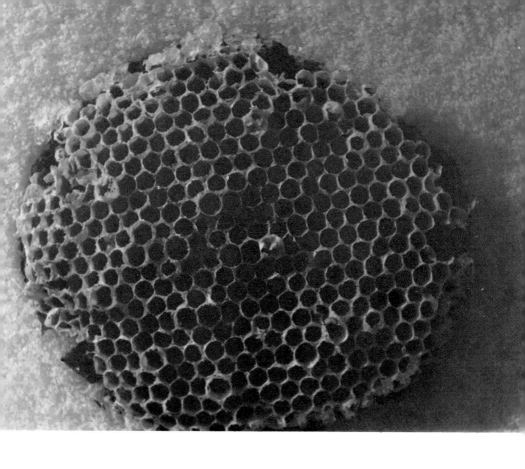

29

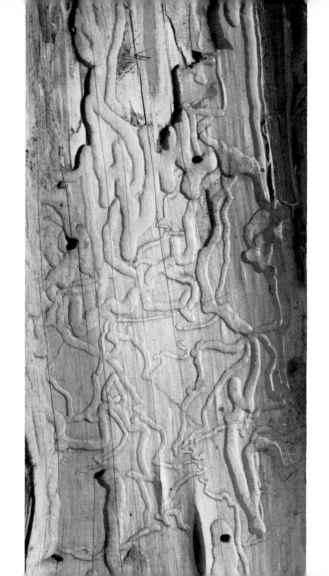

30

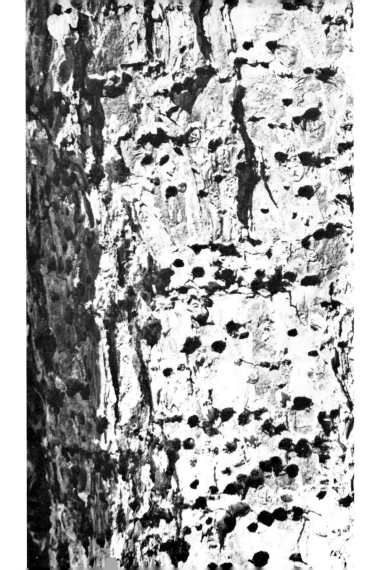

31

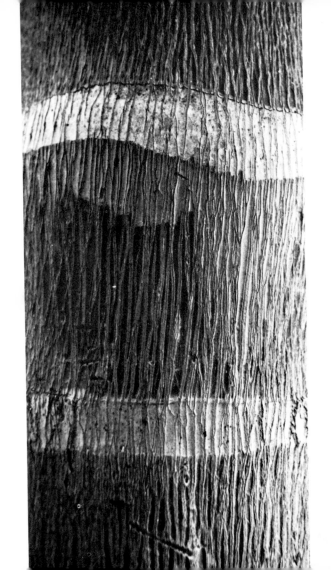

32

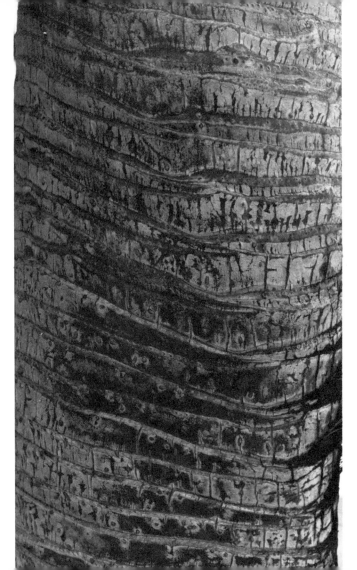

33

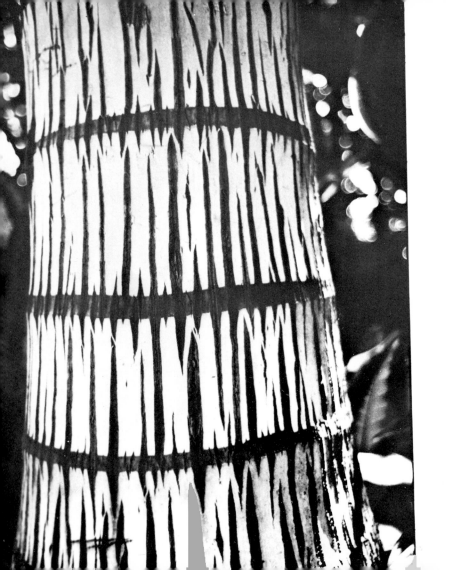

34

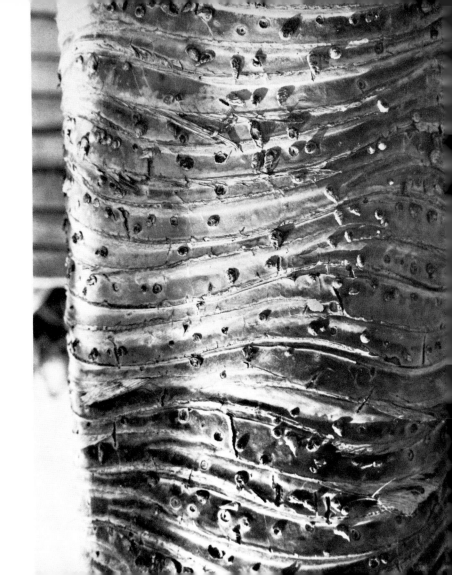

35

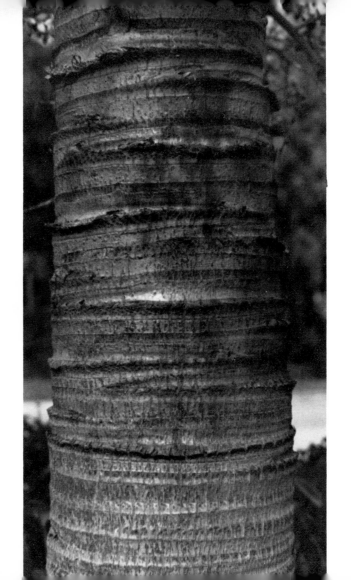

36

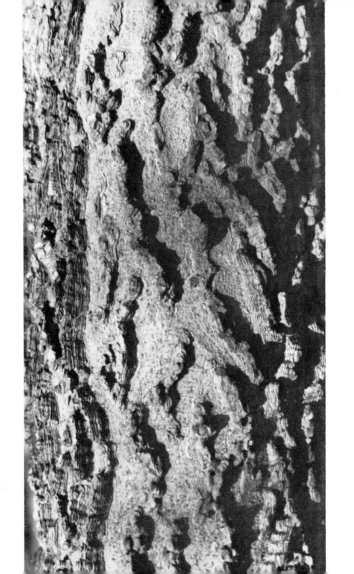

37

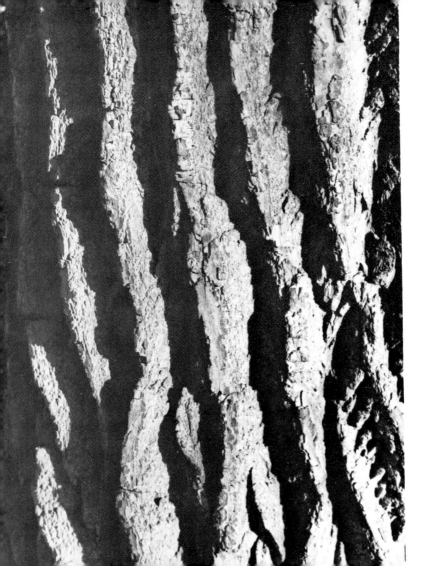

38

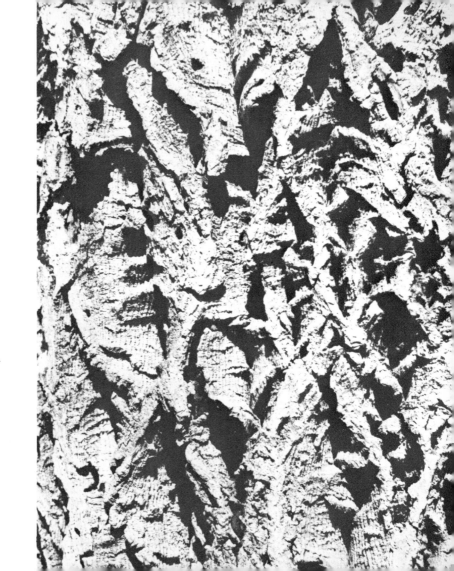

39

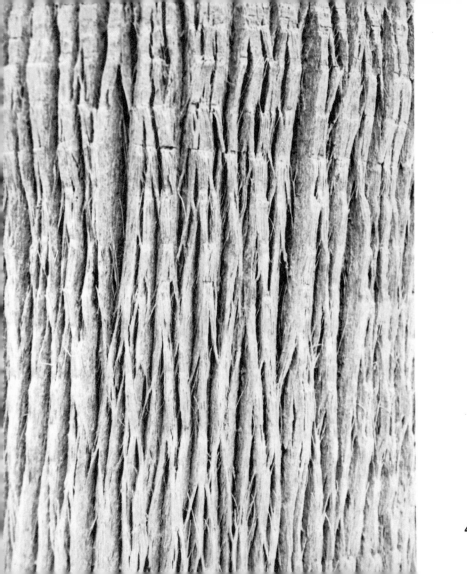

40

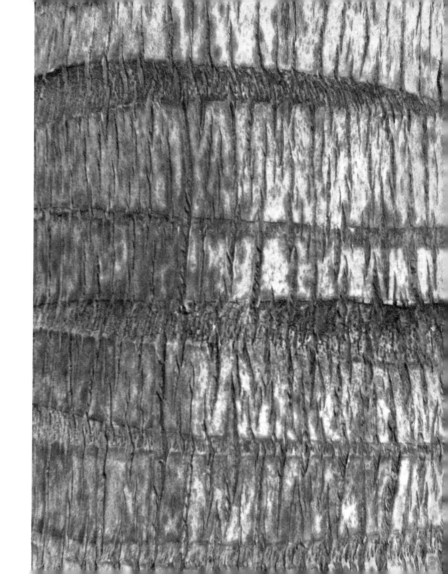

41

42

43

44

45

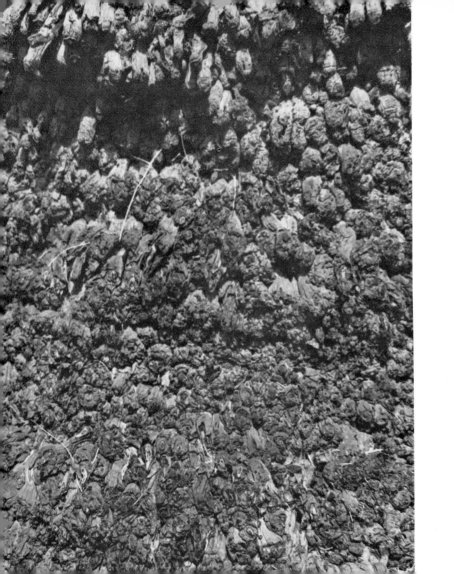

47

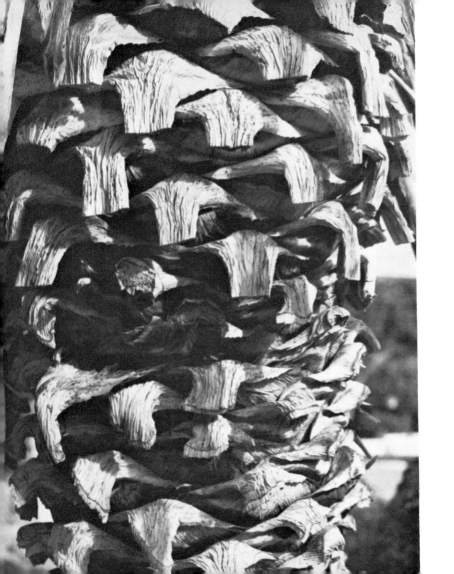

48

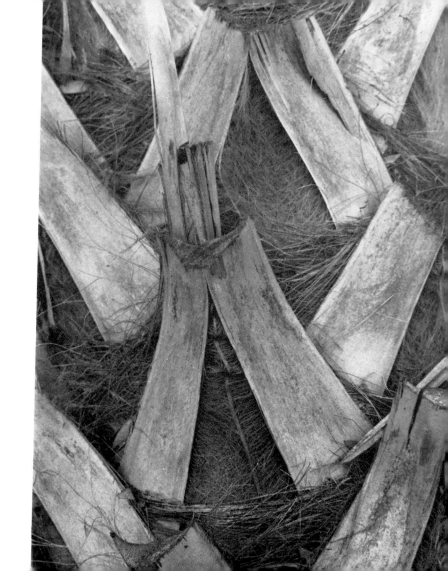

49

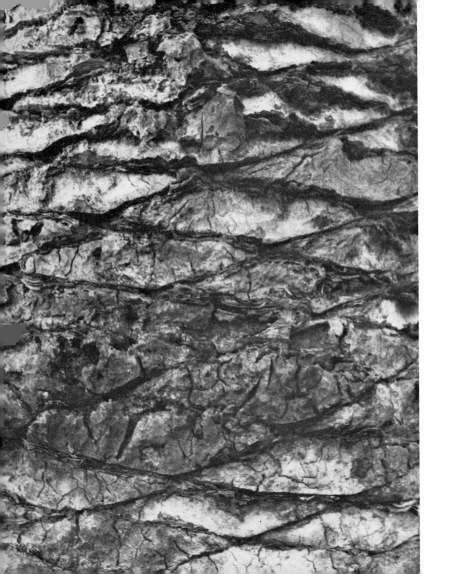

50

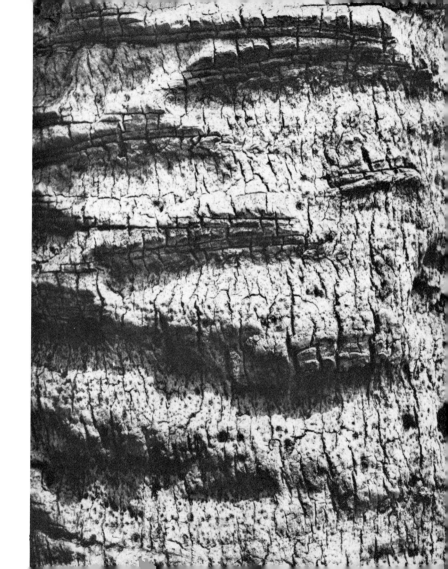

51

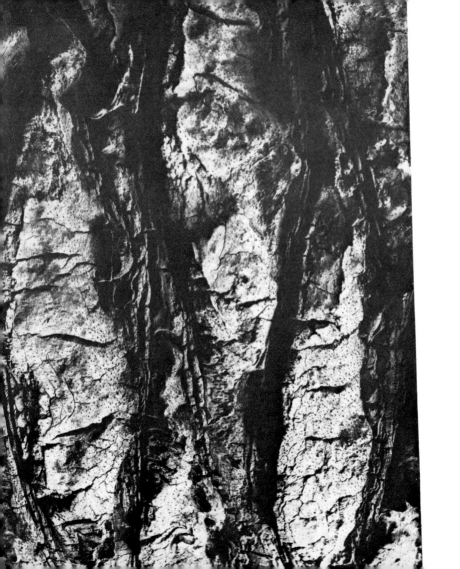

52

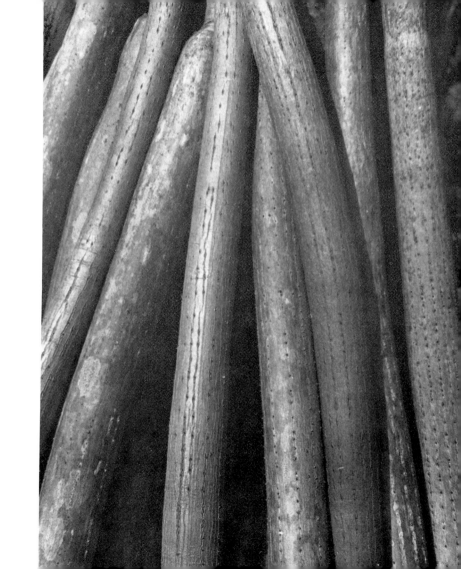

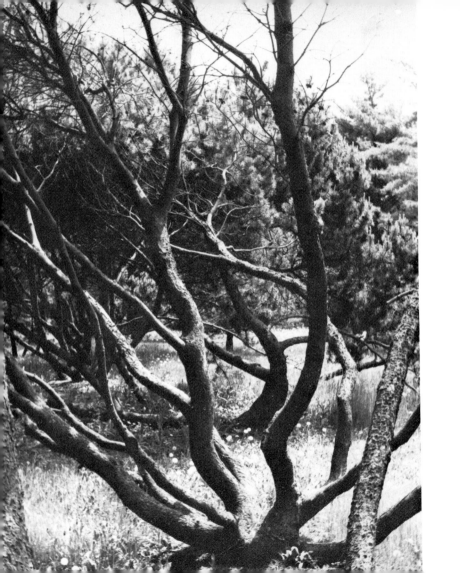

54

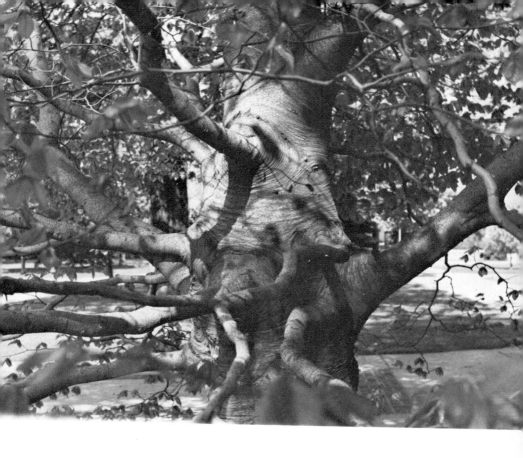

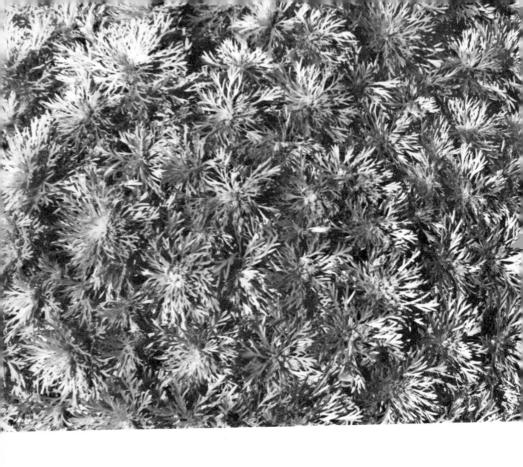

56

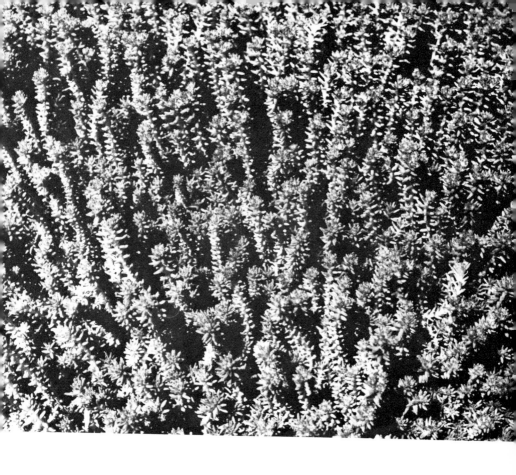

60

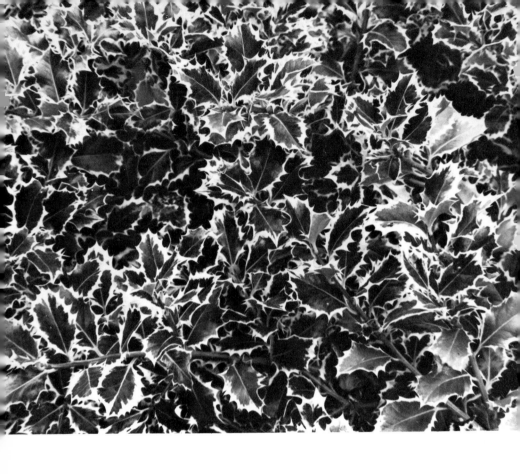

62

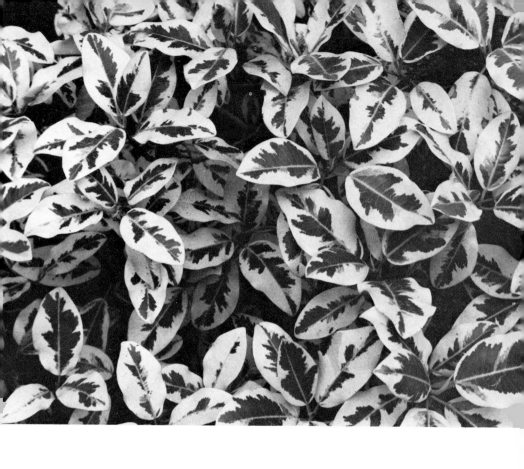

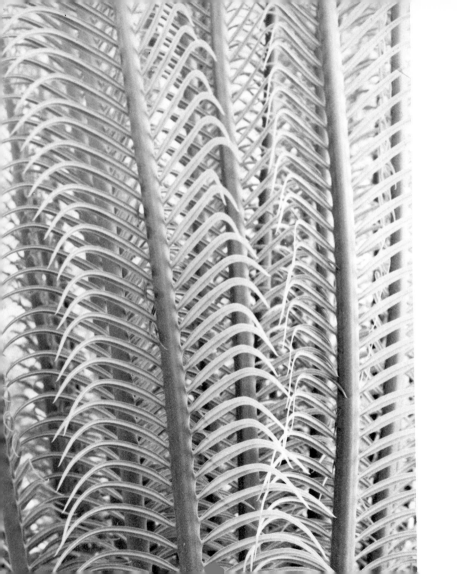

64

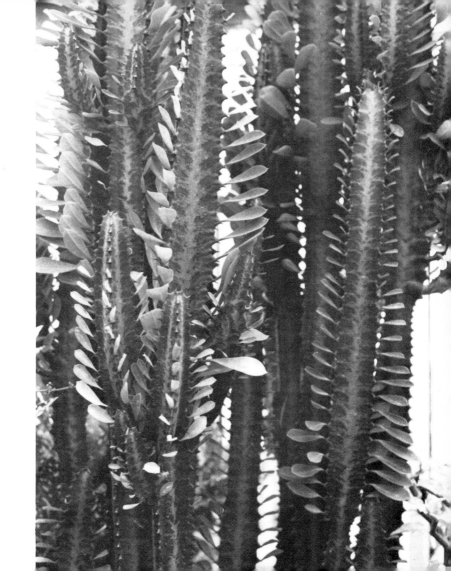

65

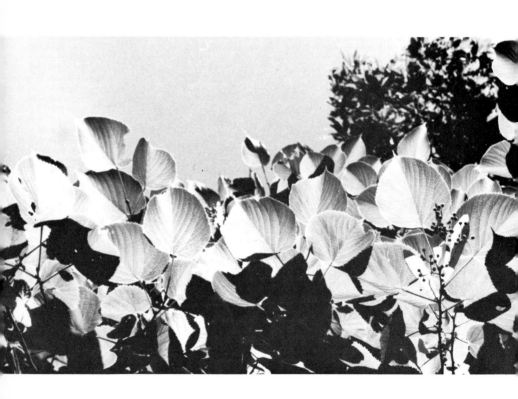

66

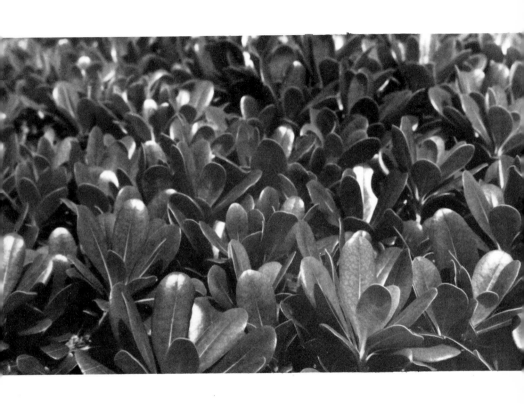

67

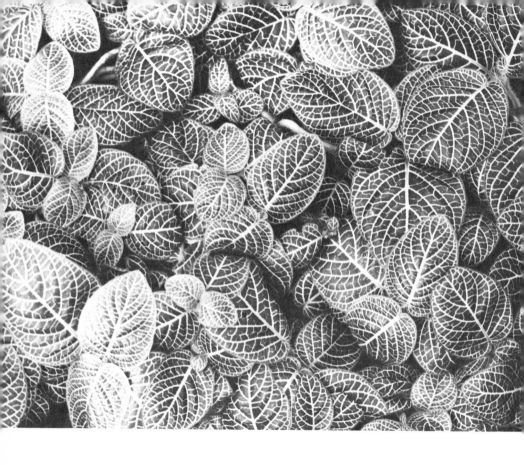

68

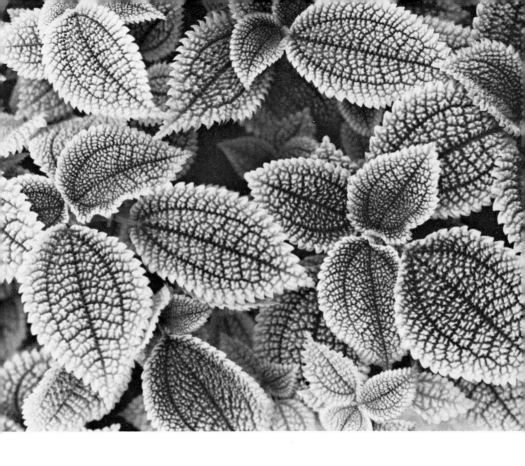

71

72

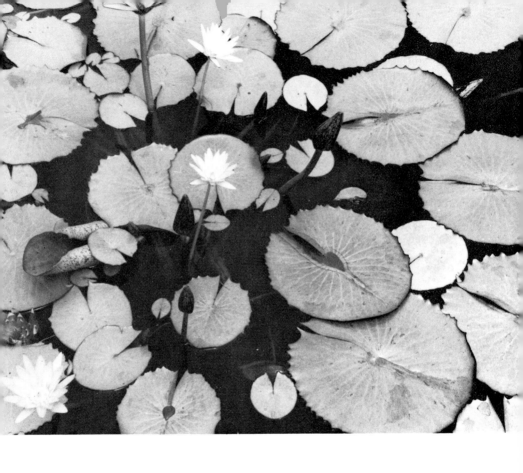

73

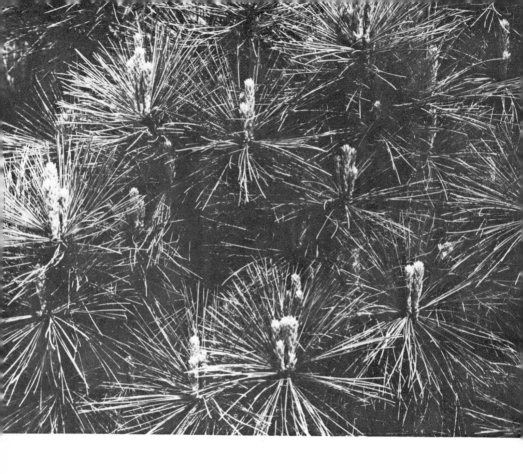

74

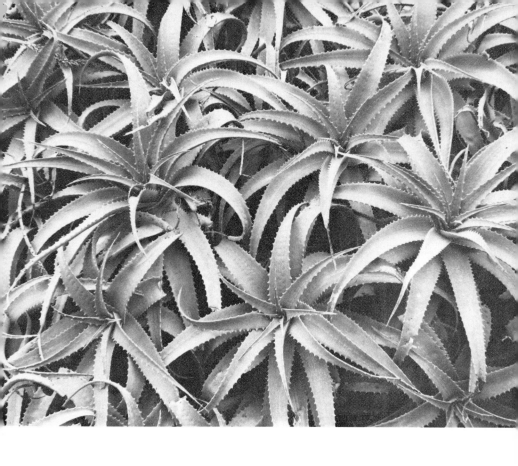

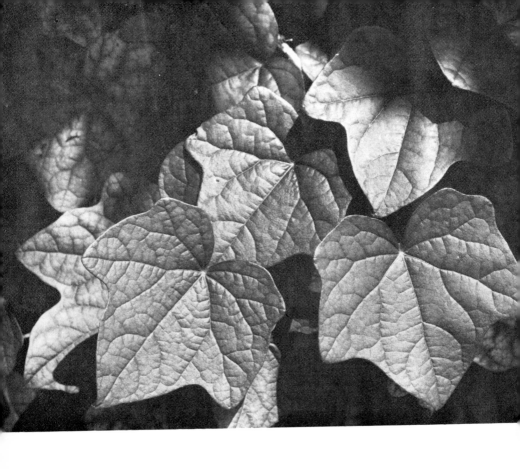

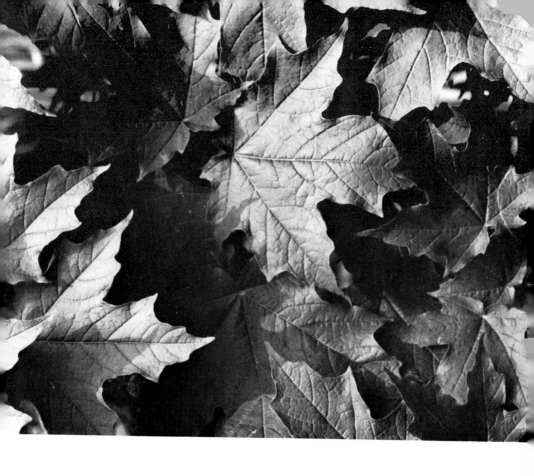

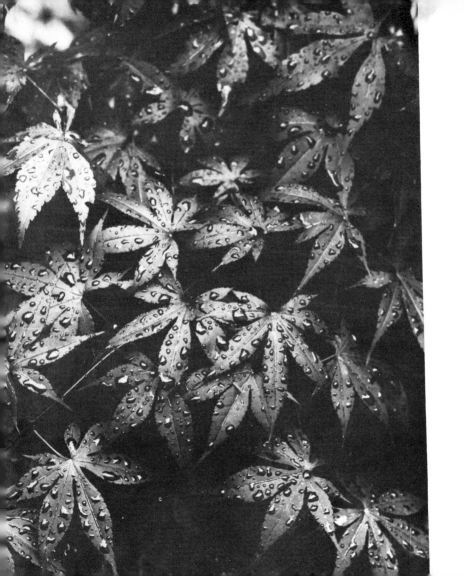

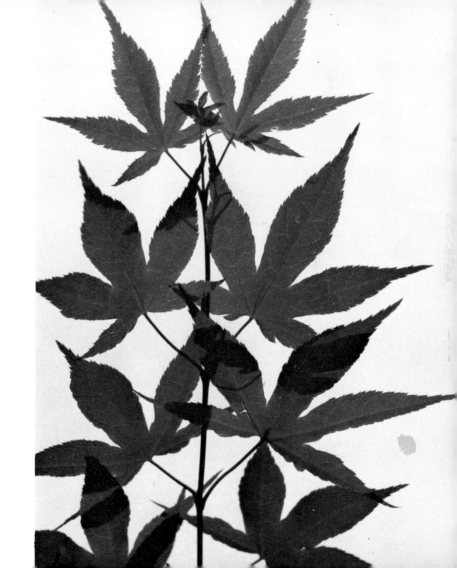

79

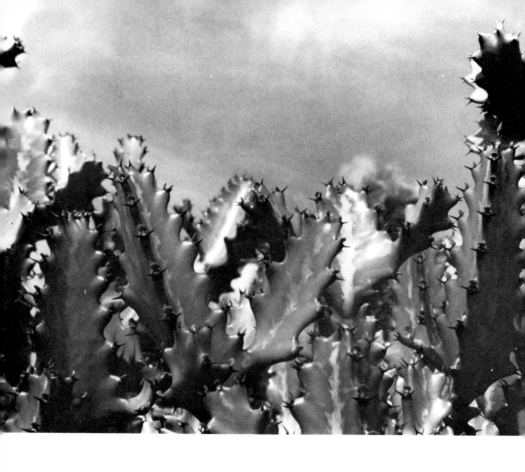

80

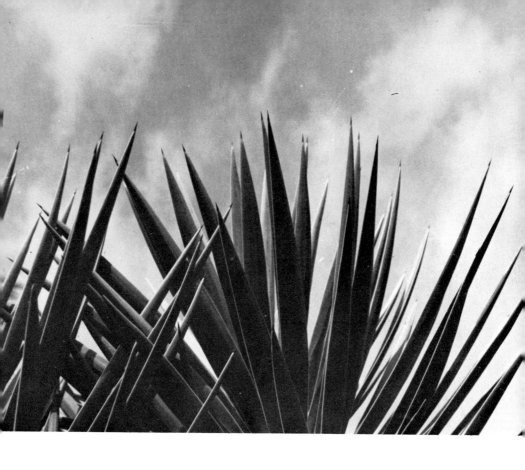

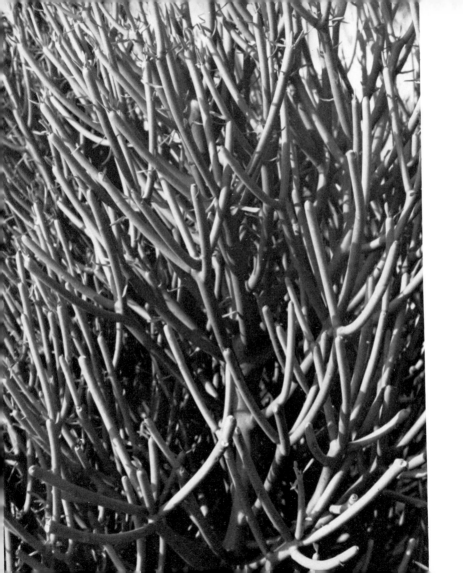

82

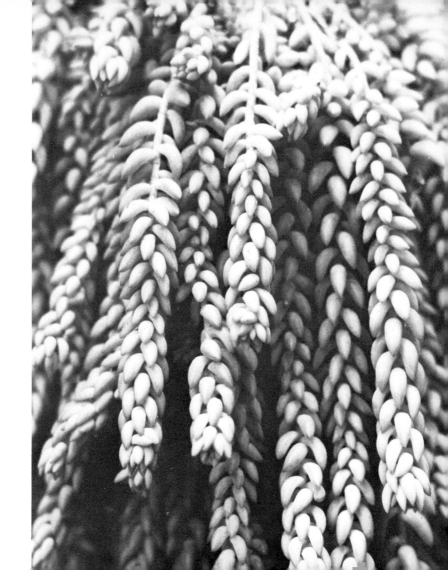

83

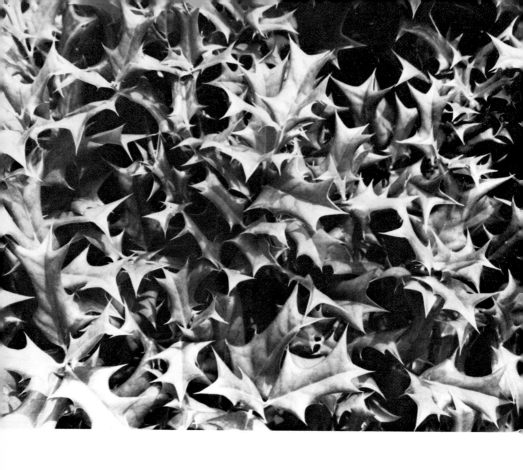

84

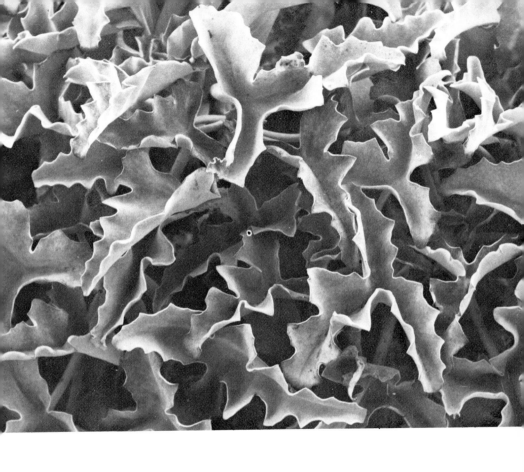

85

89

90

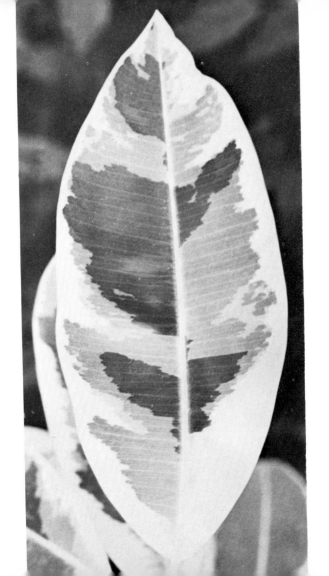

94

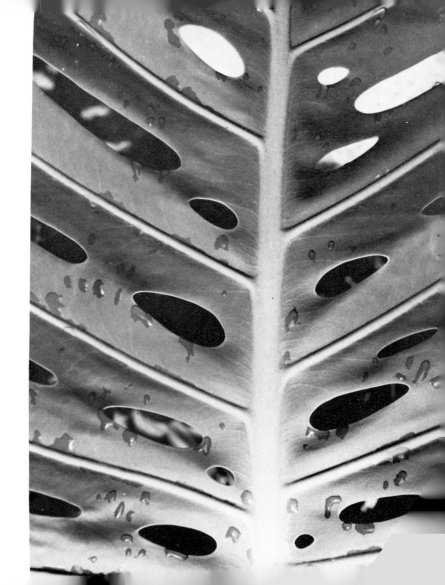

95

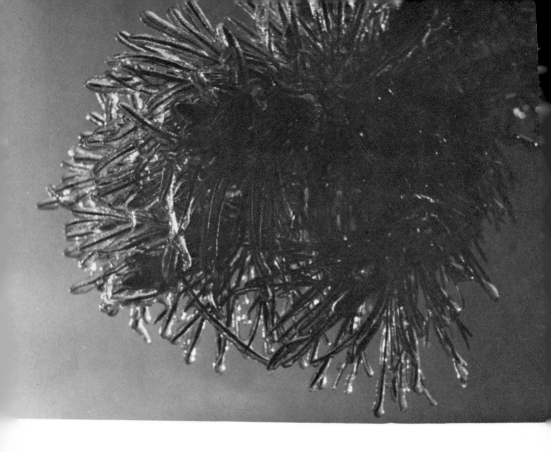

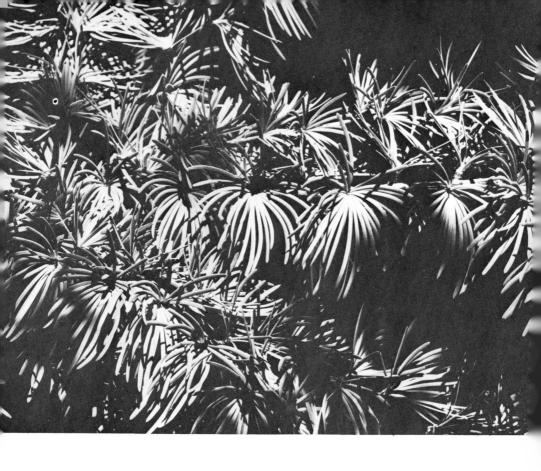

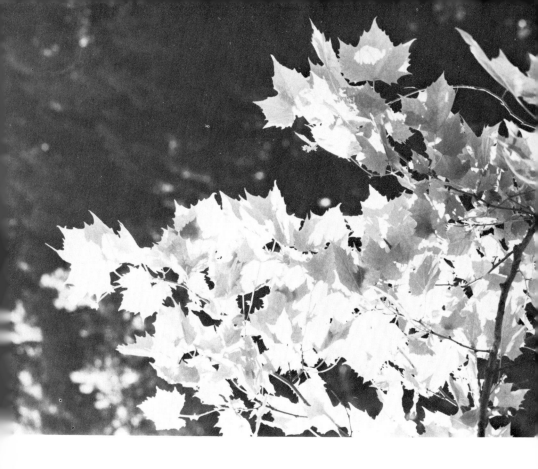

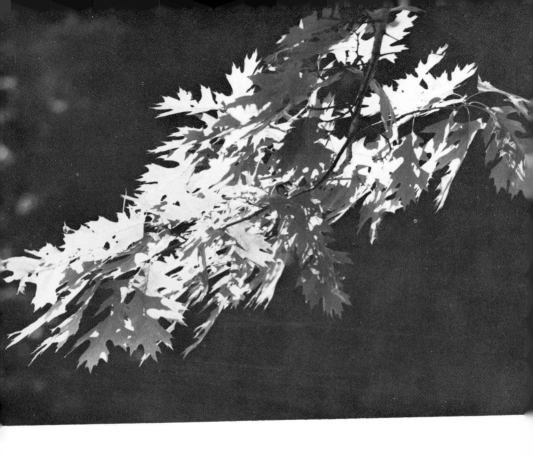

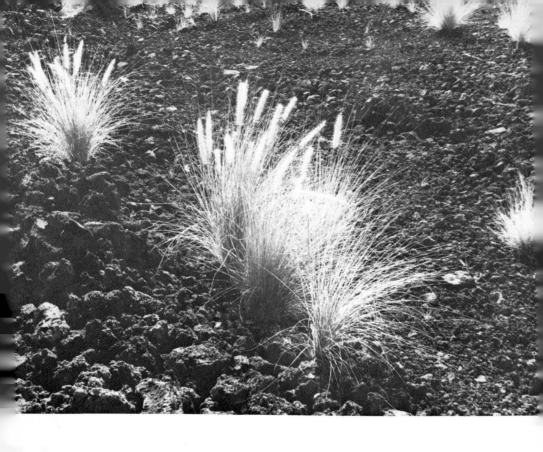

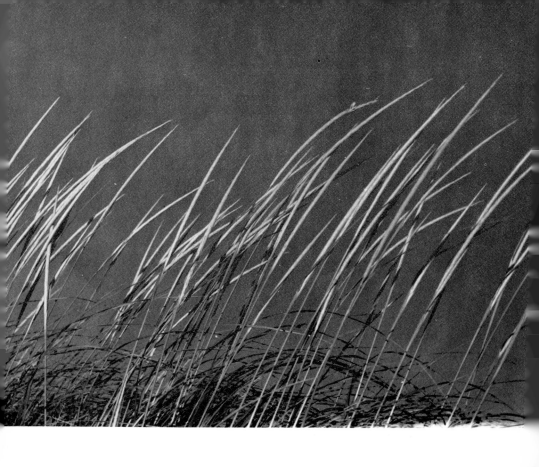

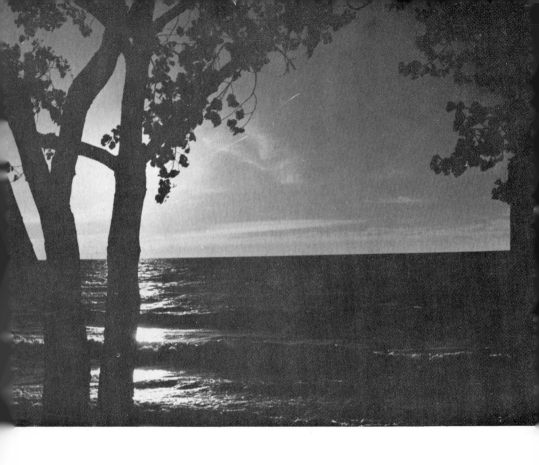

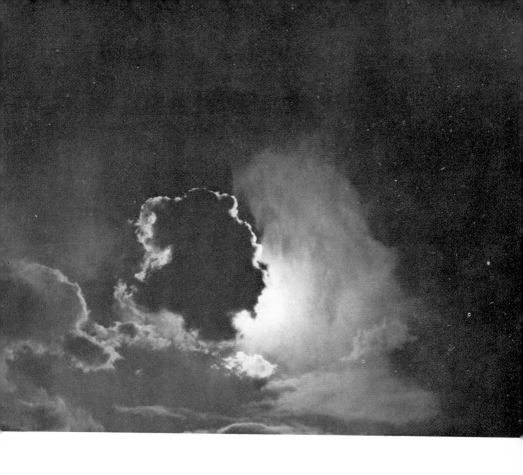

103